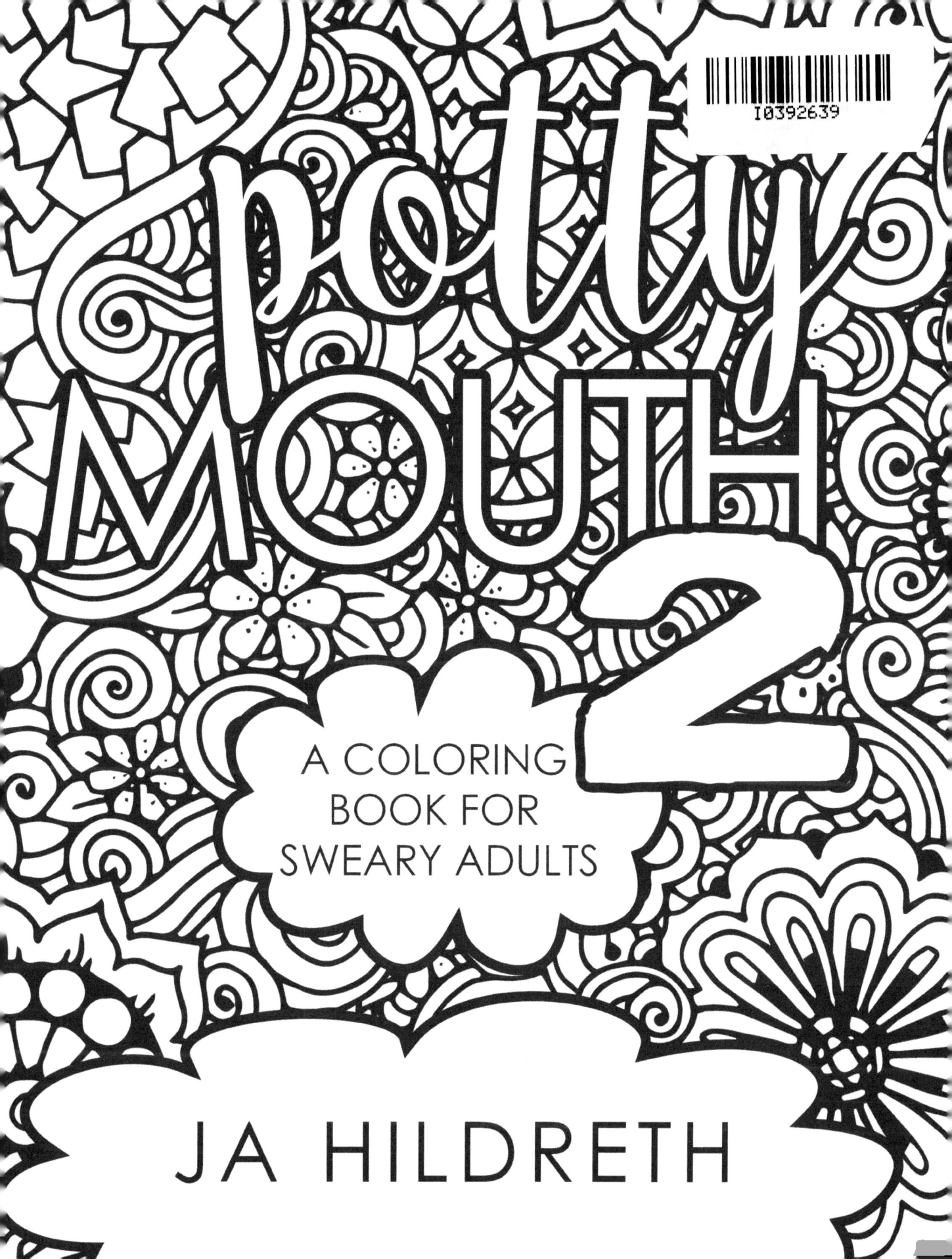

Potty Mouth 2
Coloring Book for Adults

Copyright © 2016 by JA Hildreth

Cover and designs by: Jessica Hildreth/Creative Book Concepts
jessicahildrethdesigns.com

All rights reserved. No part of this book may be reproduced in any form by any electronic or mechanical means including photocopying, recording, or information storage and retrieval without permission in writing from the author.

ISBN-13: 978-1537198620

Printed in U.S.A

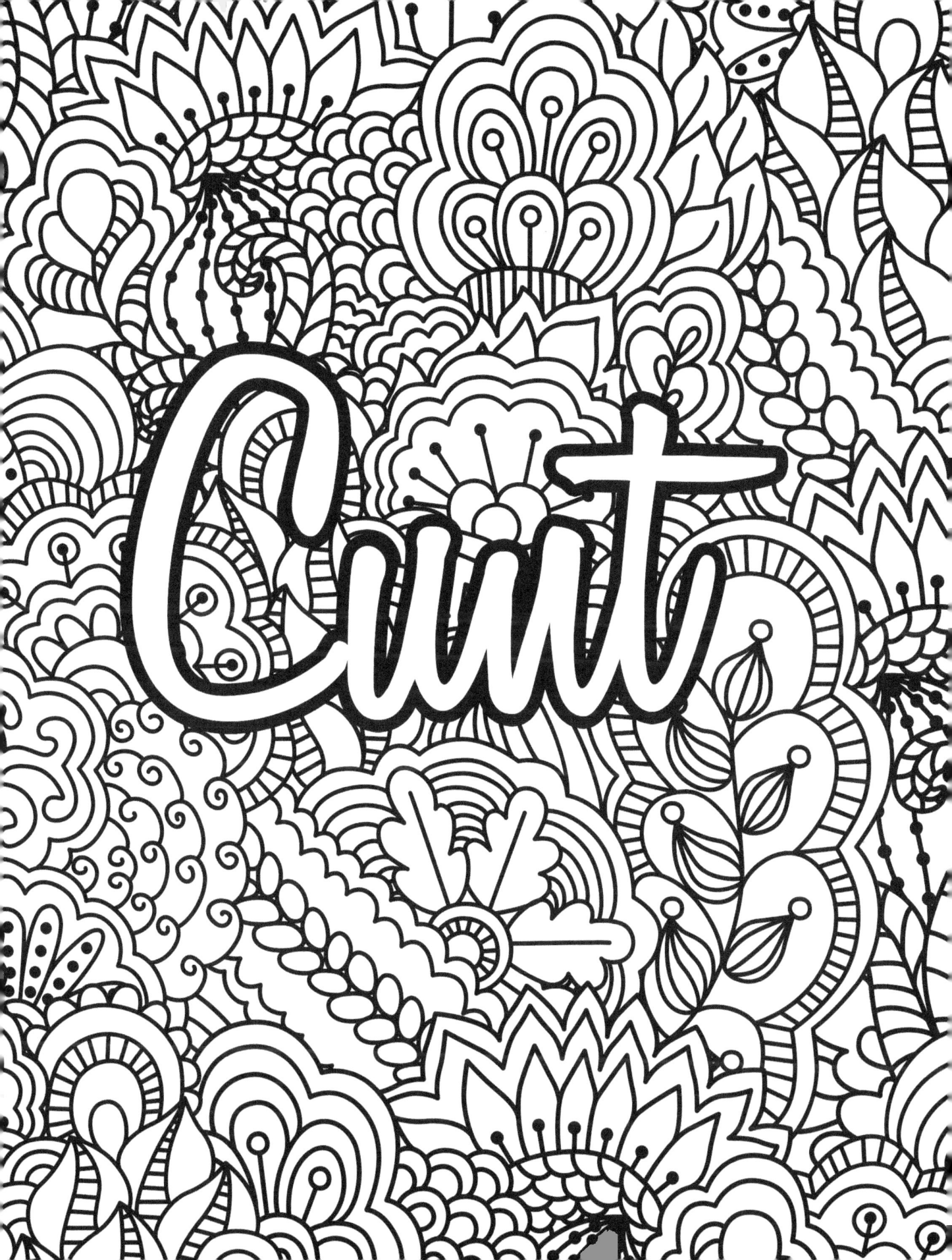

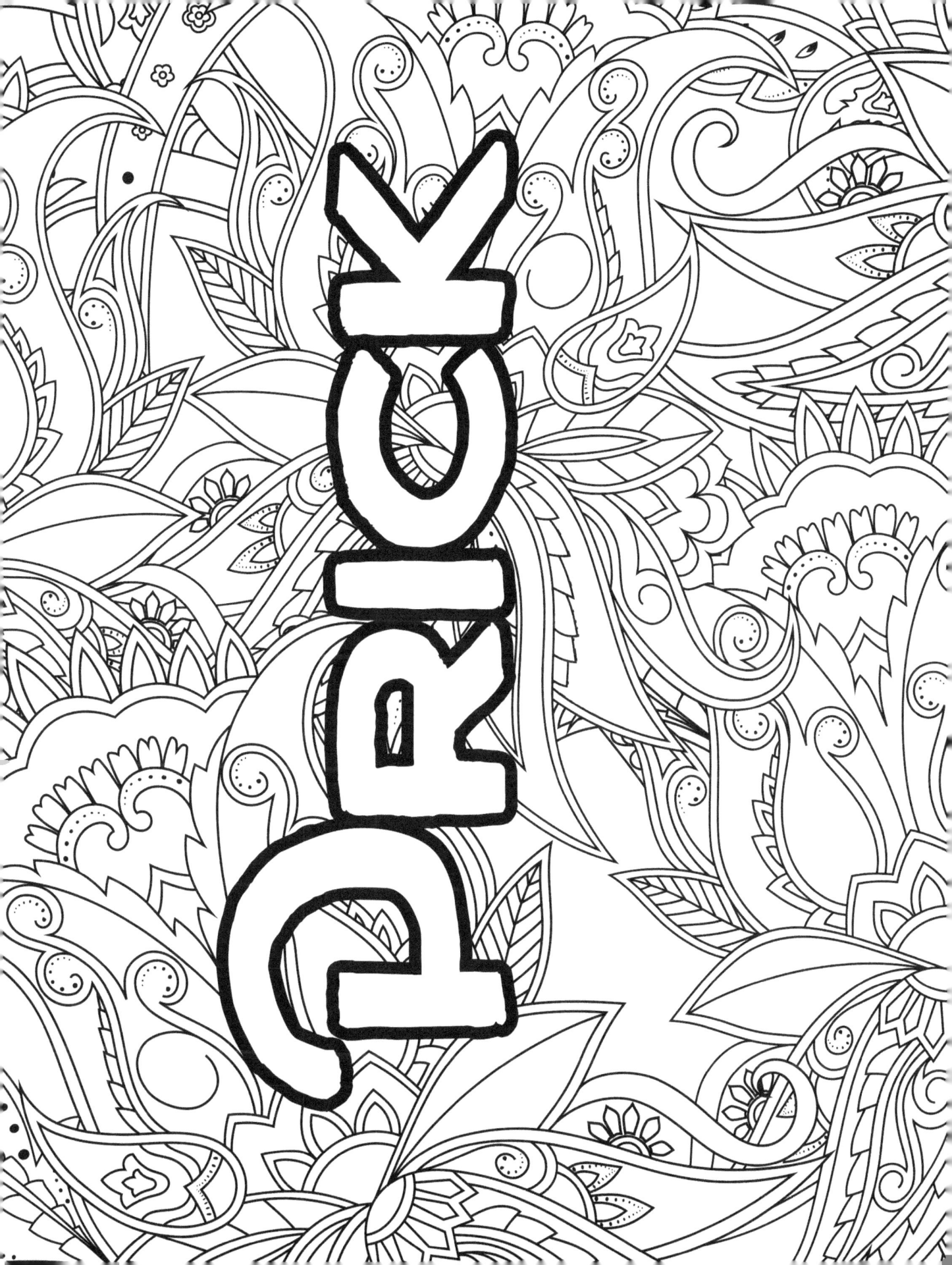

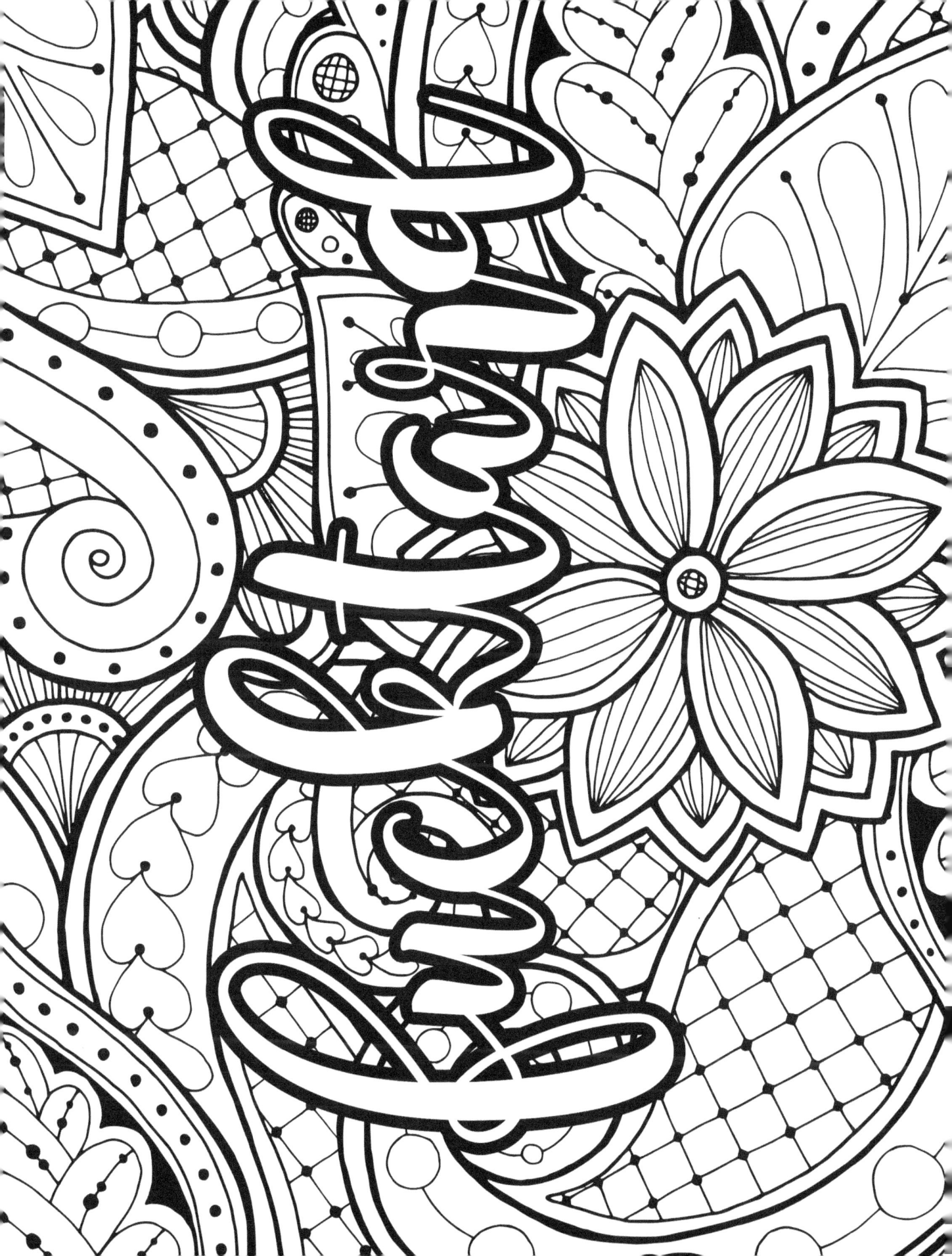

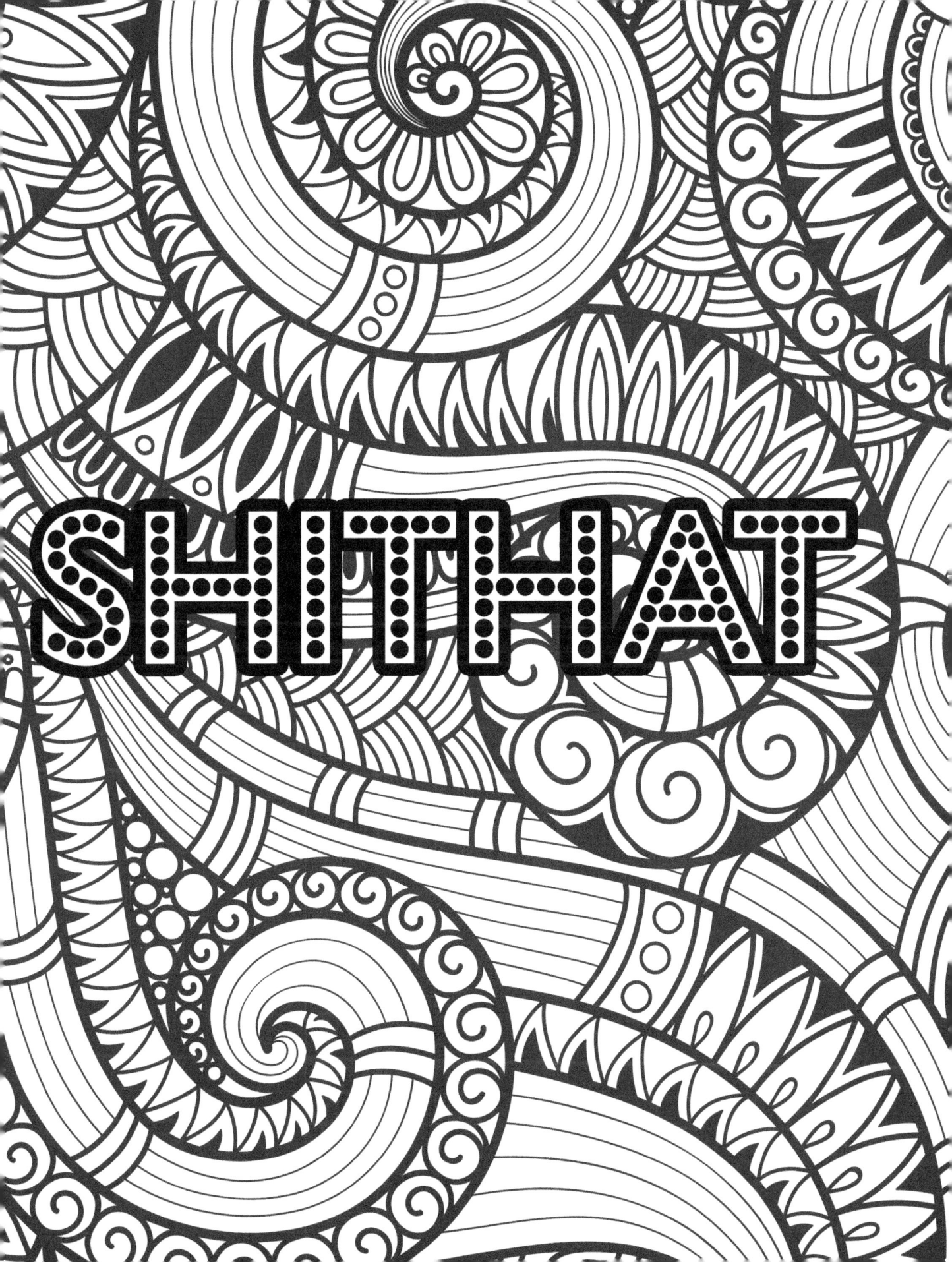

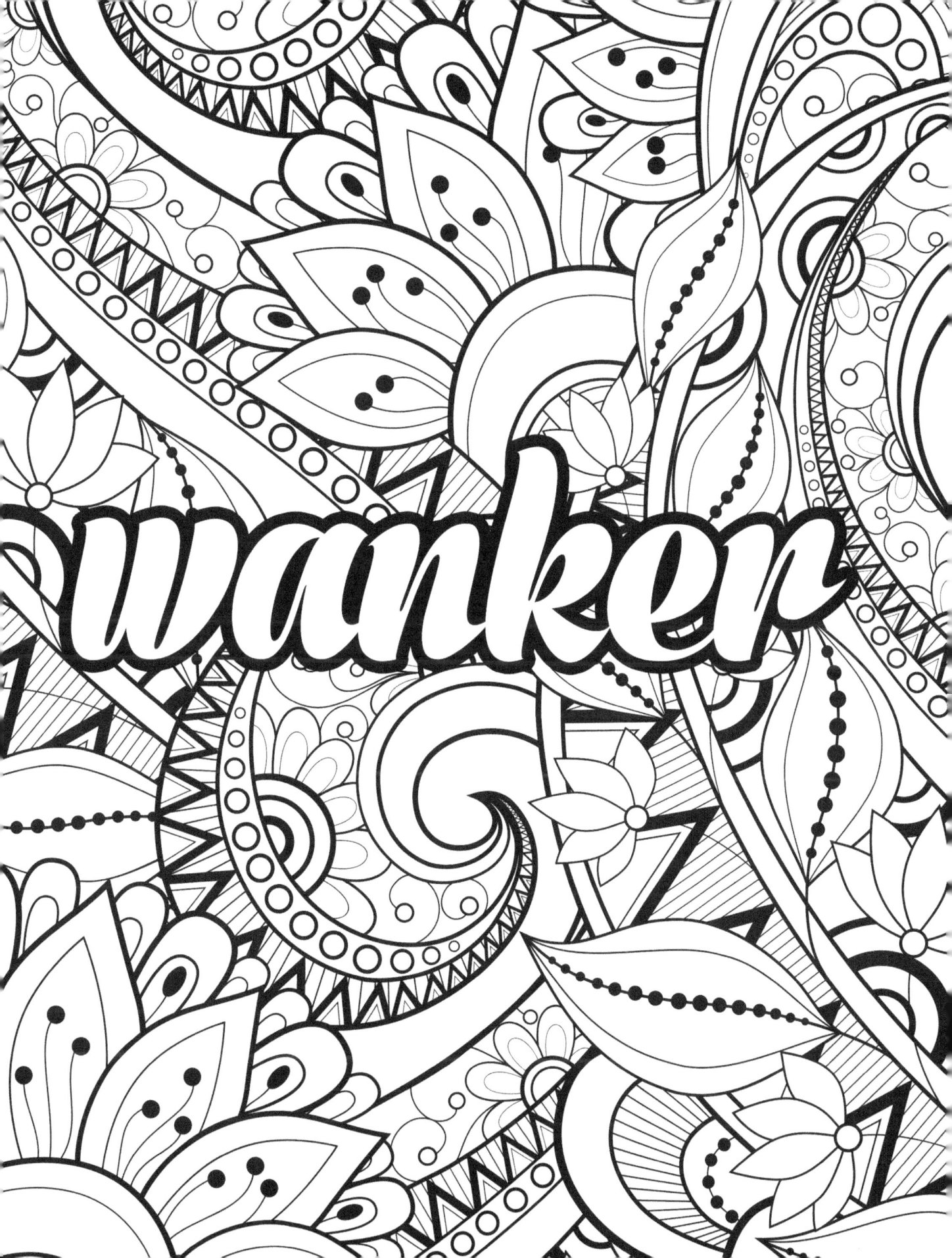

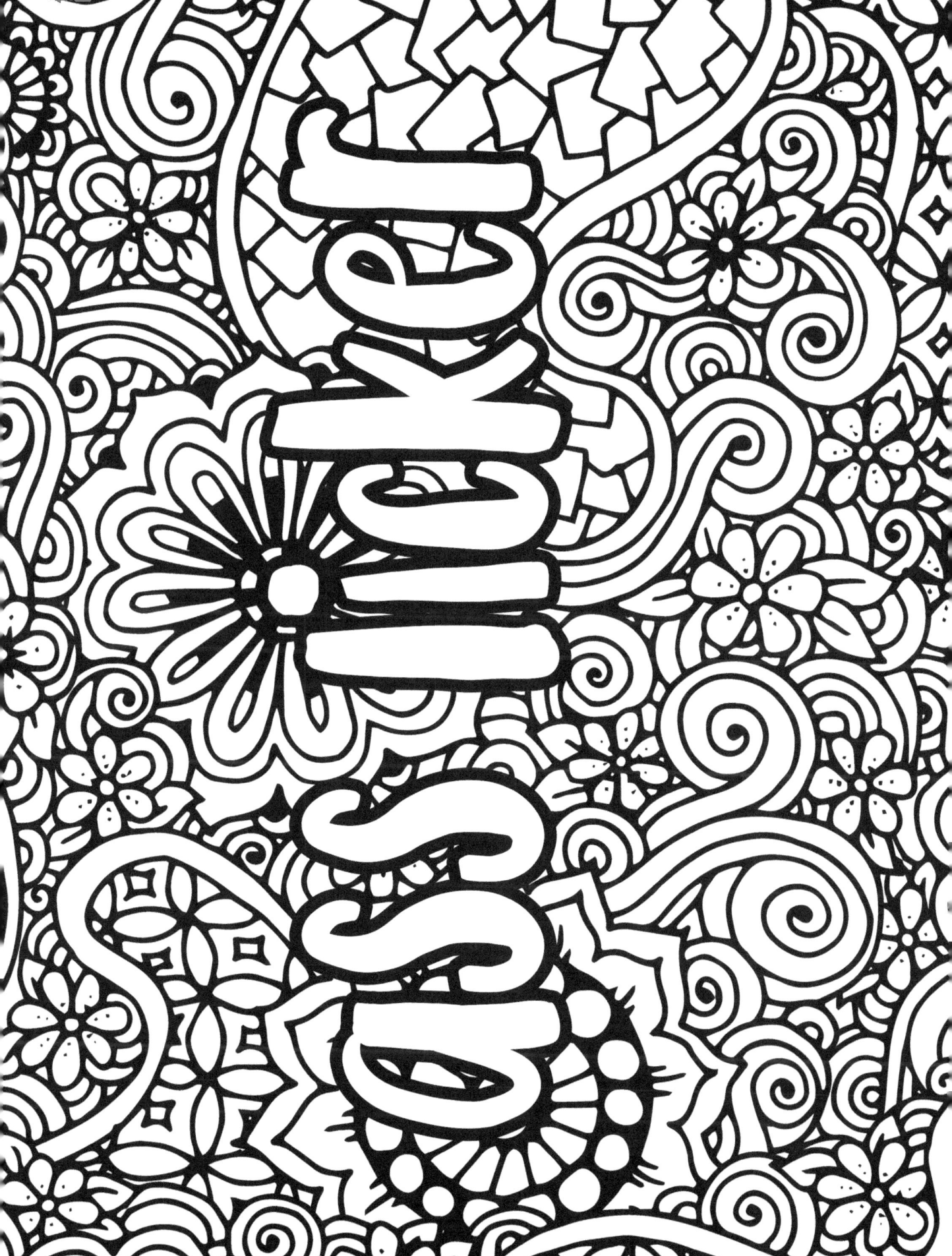

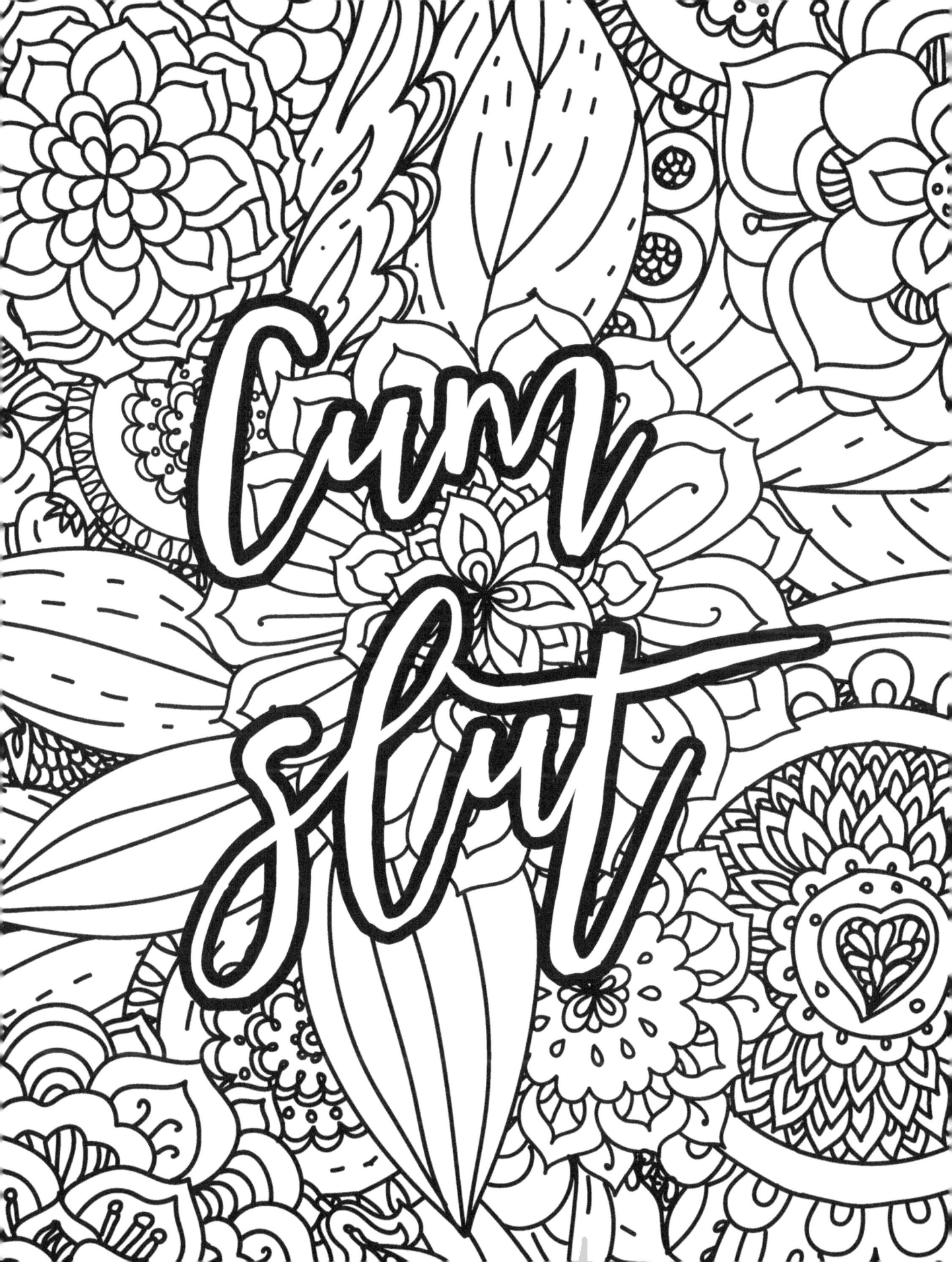

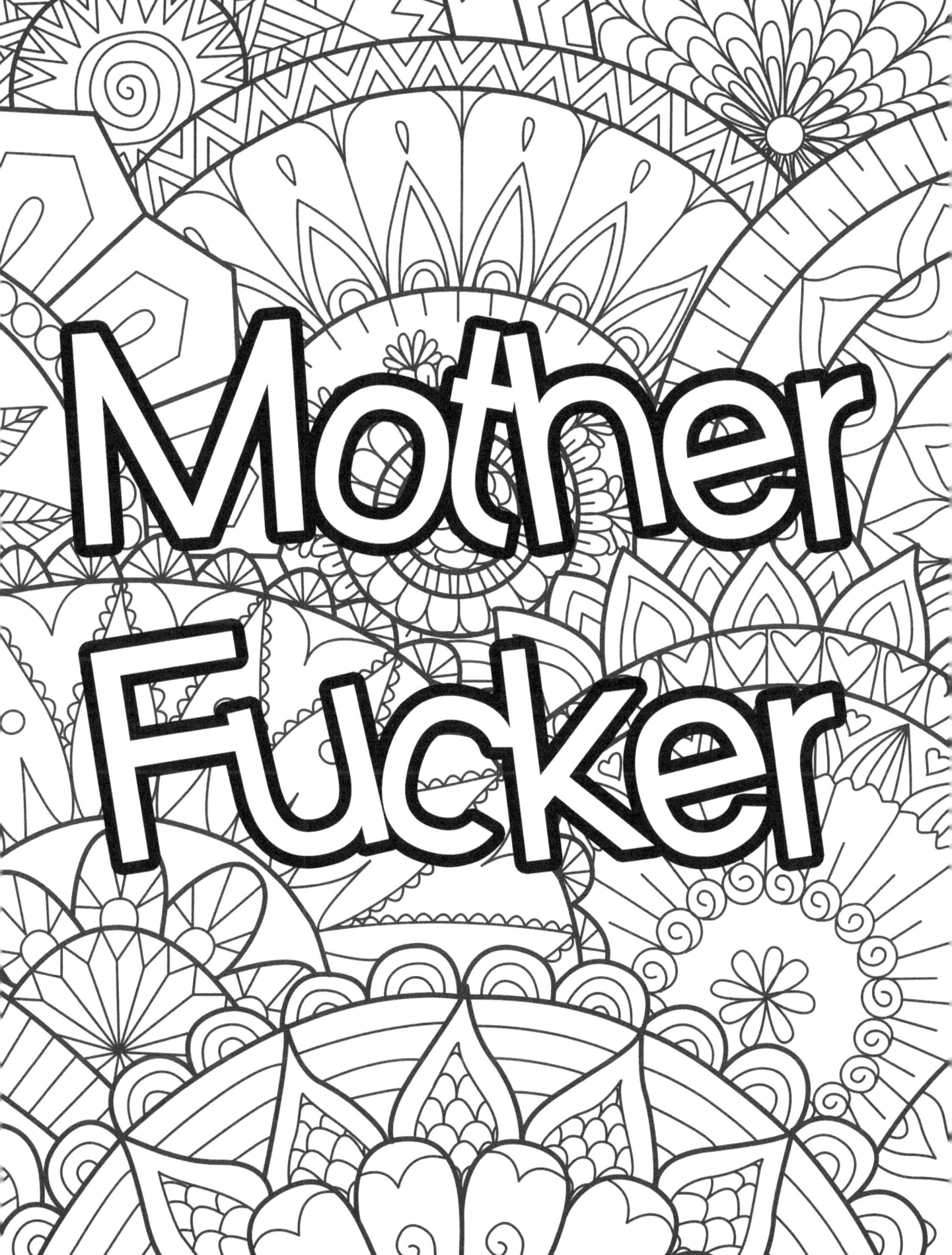

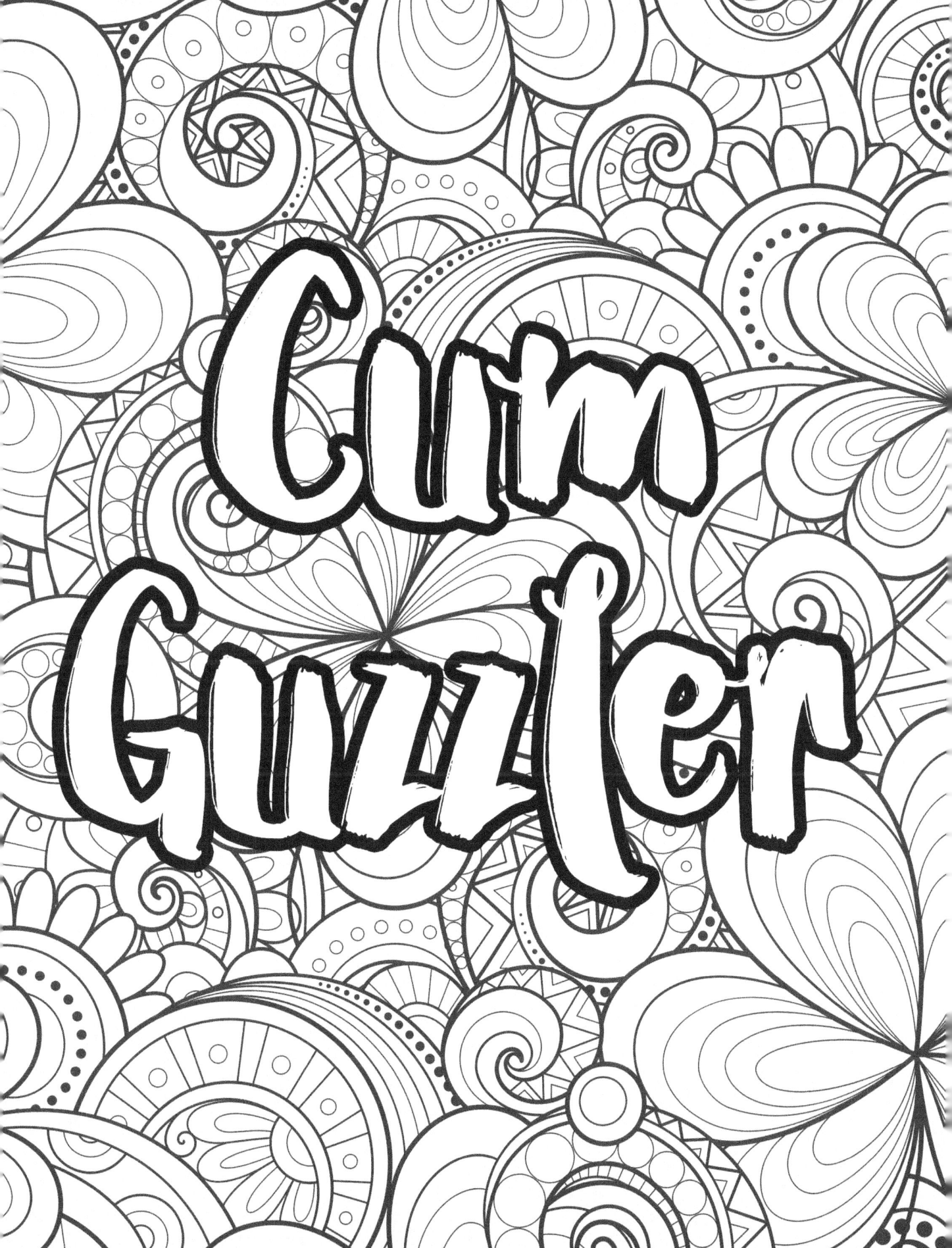

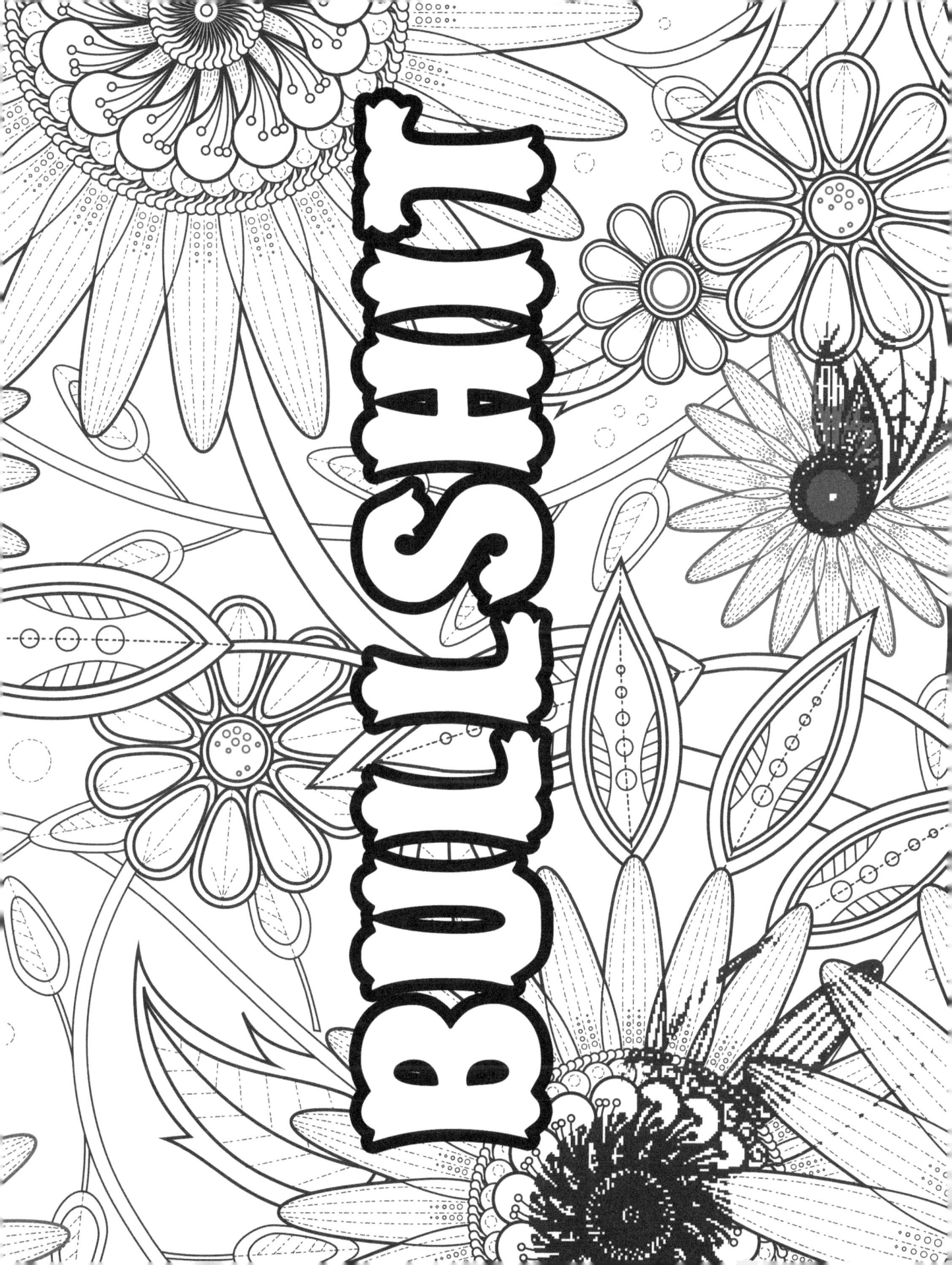

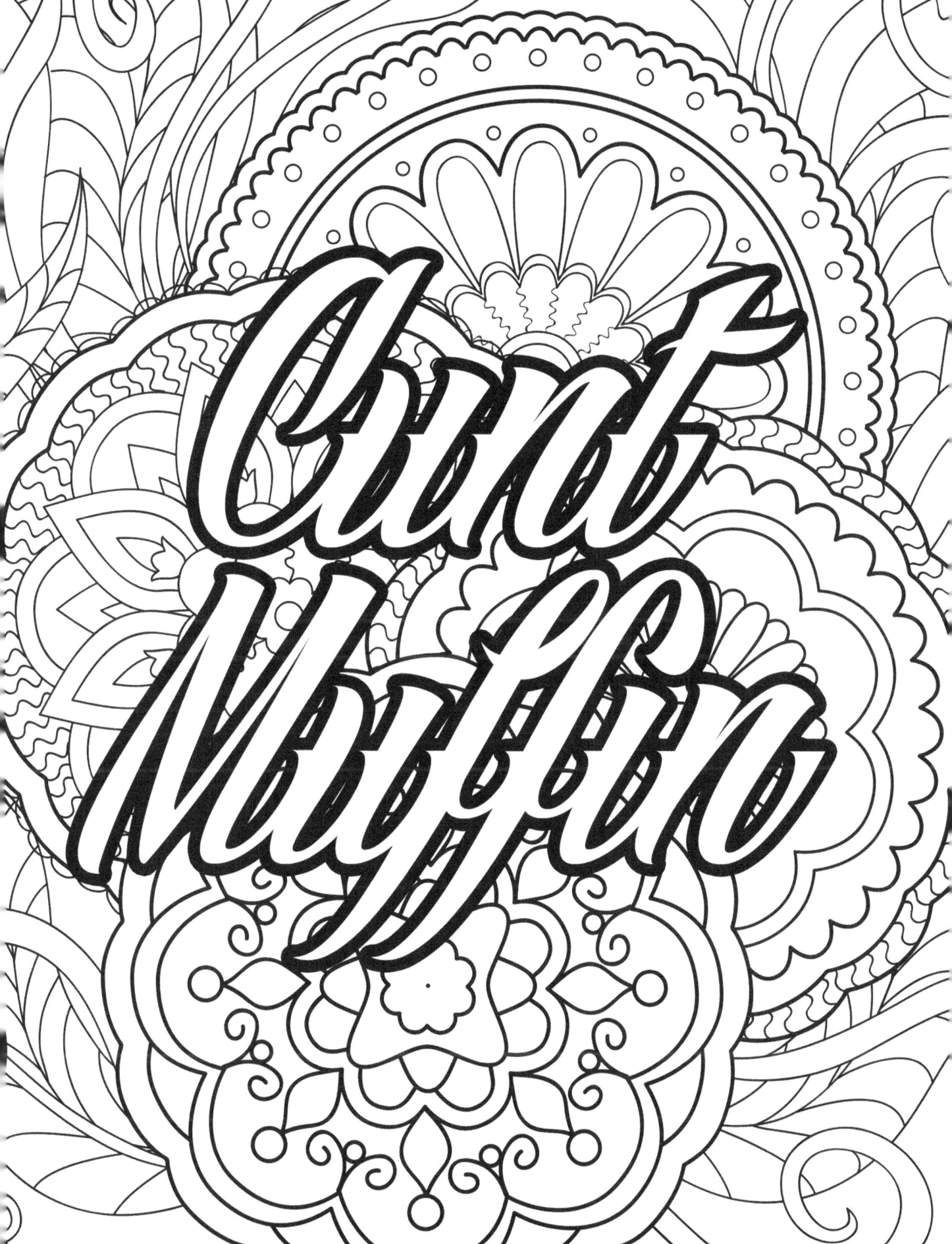

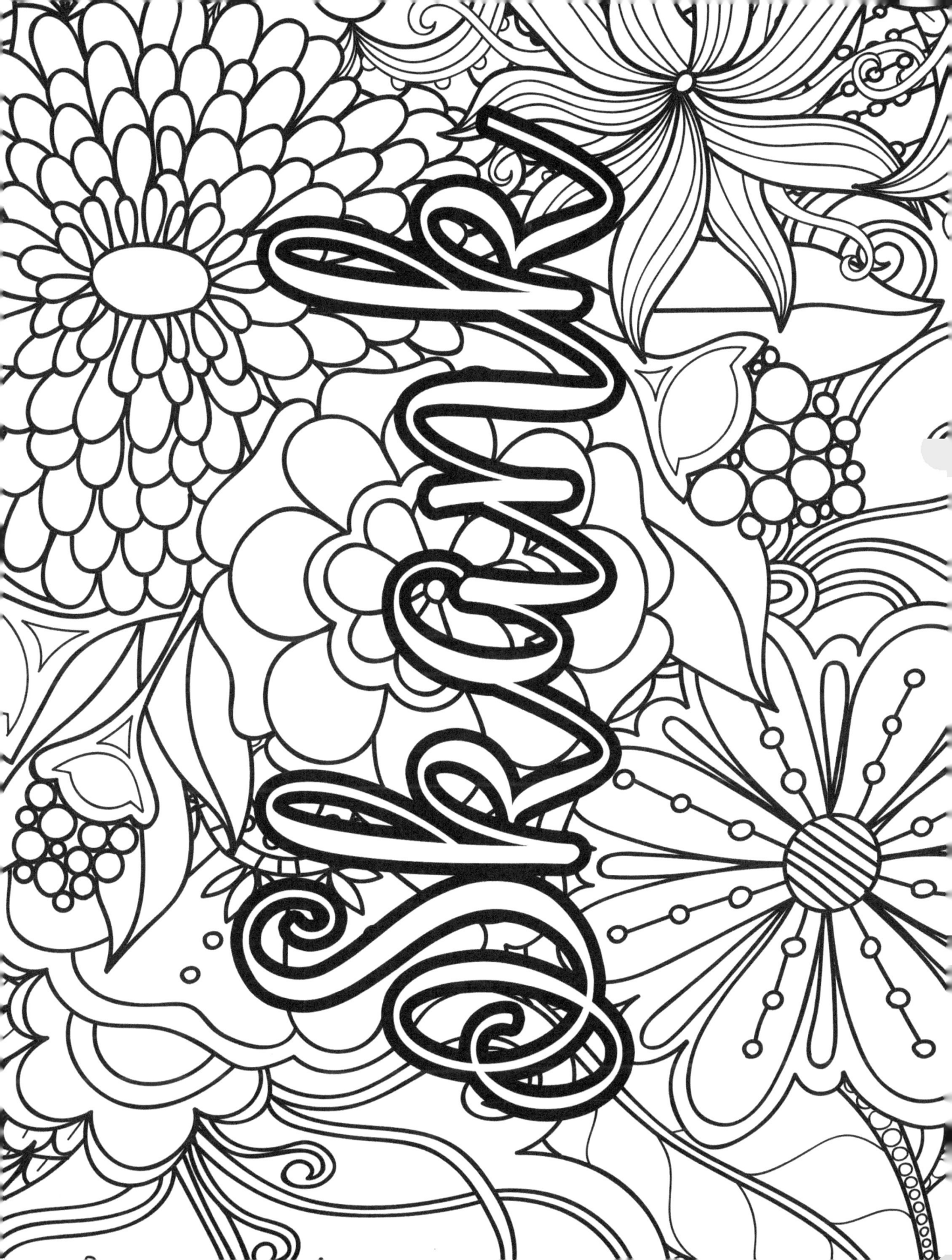

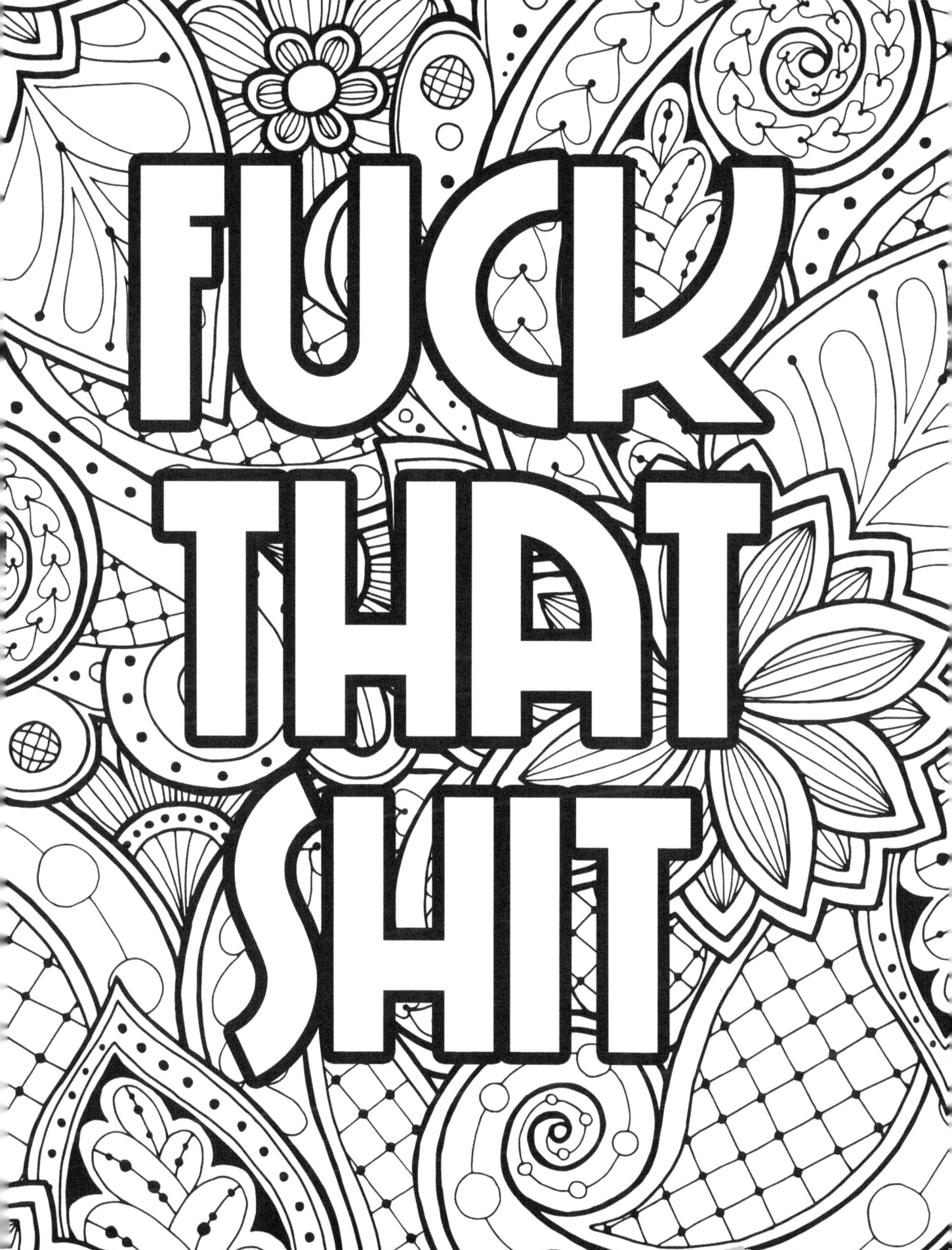

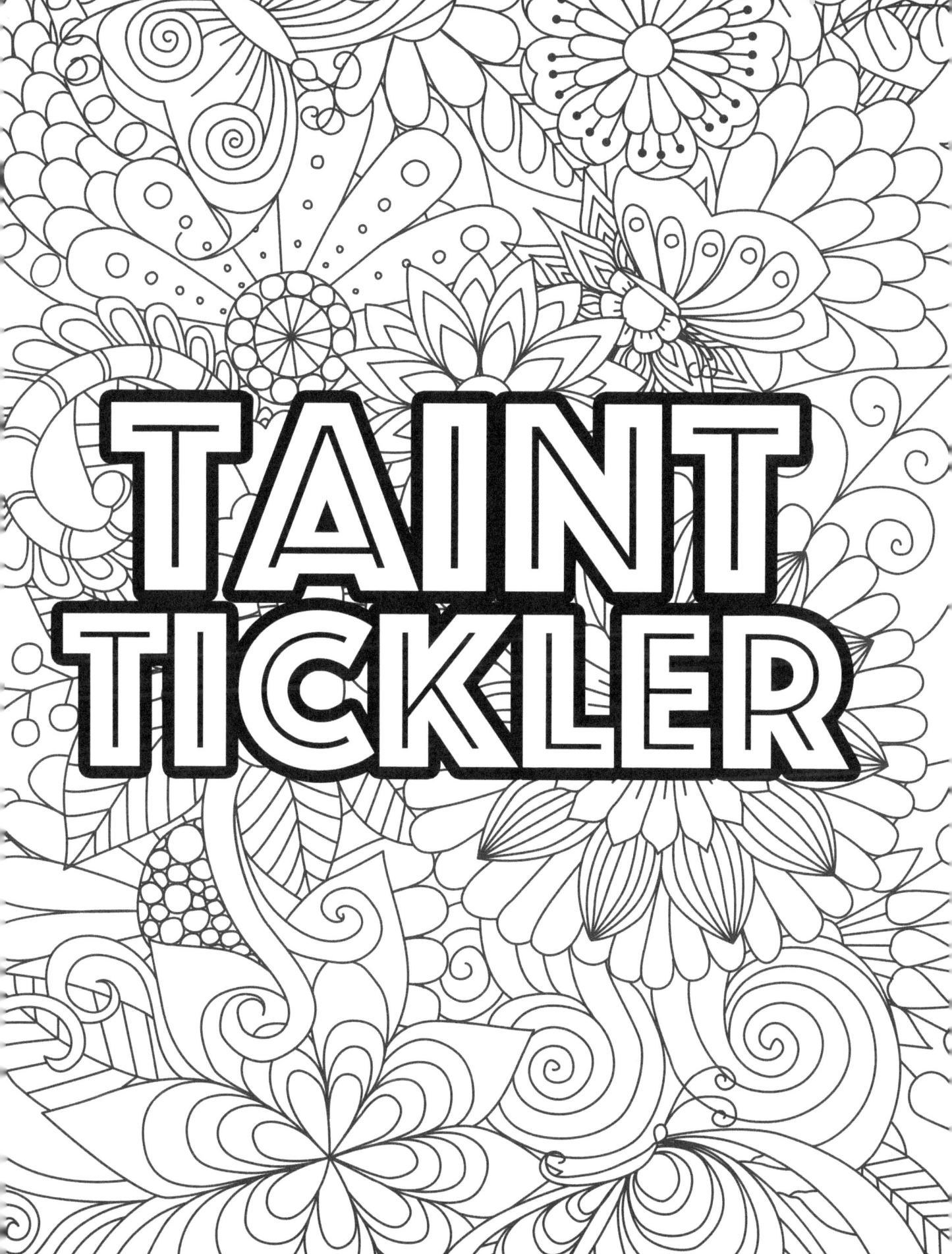

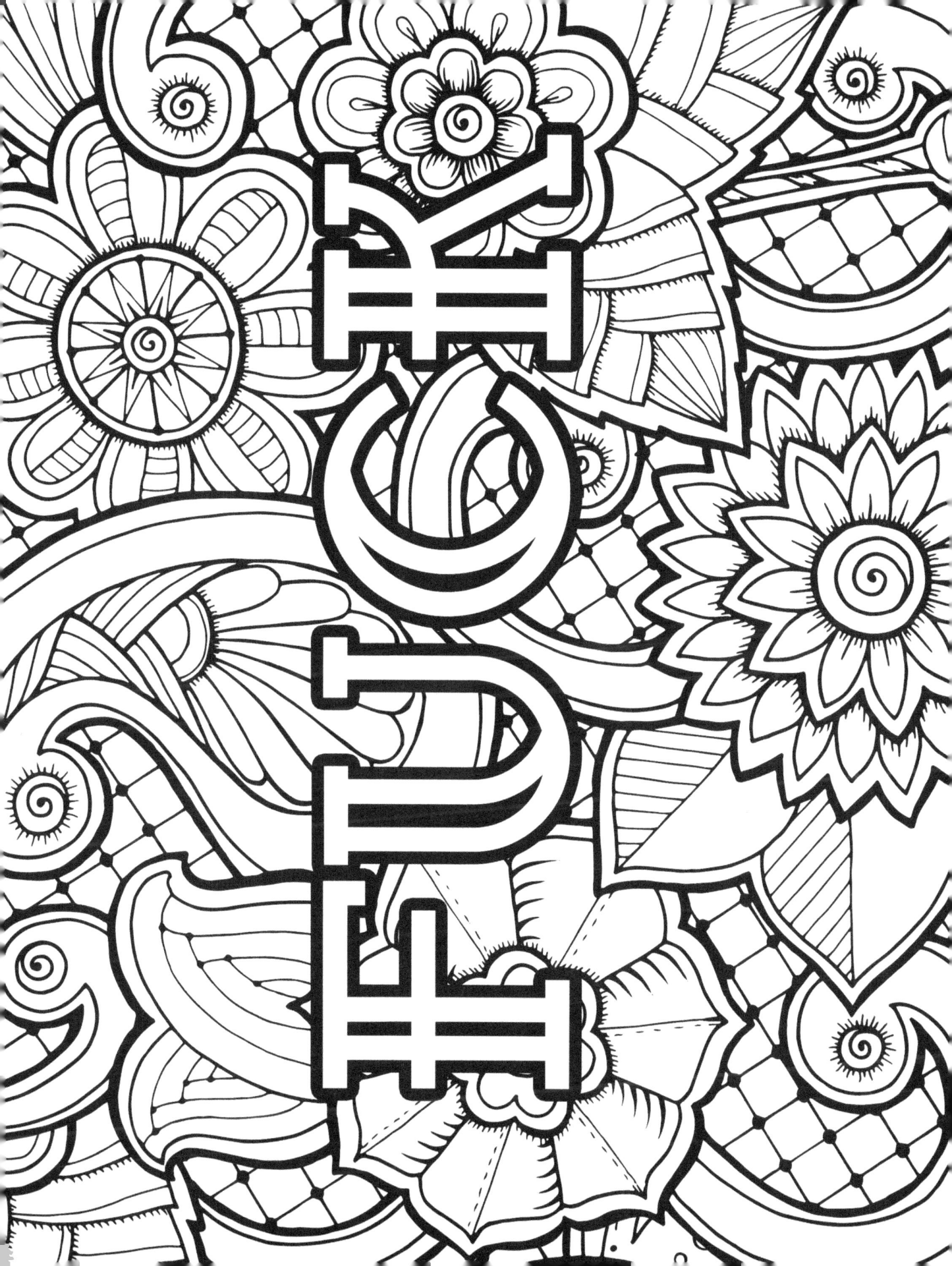

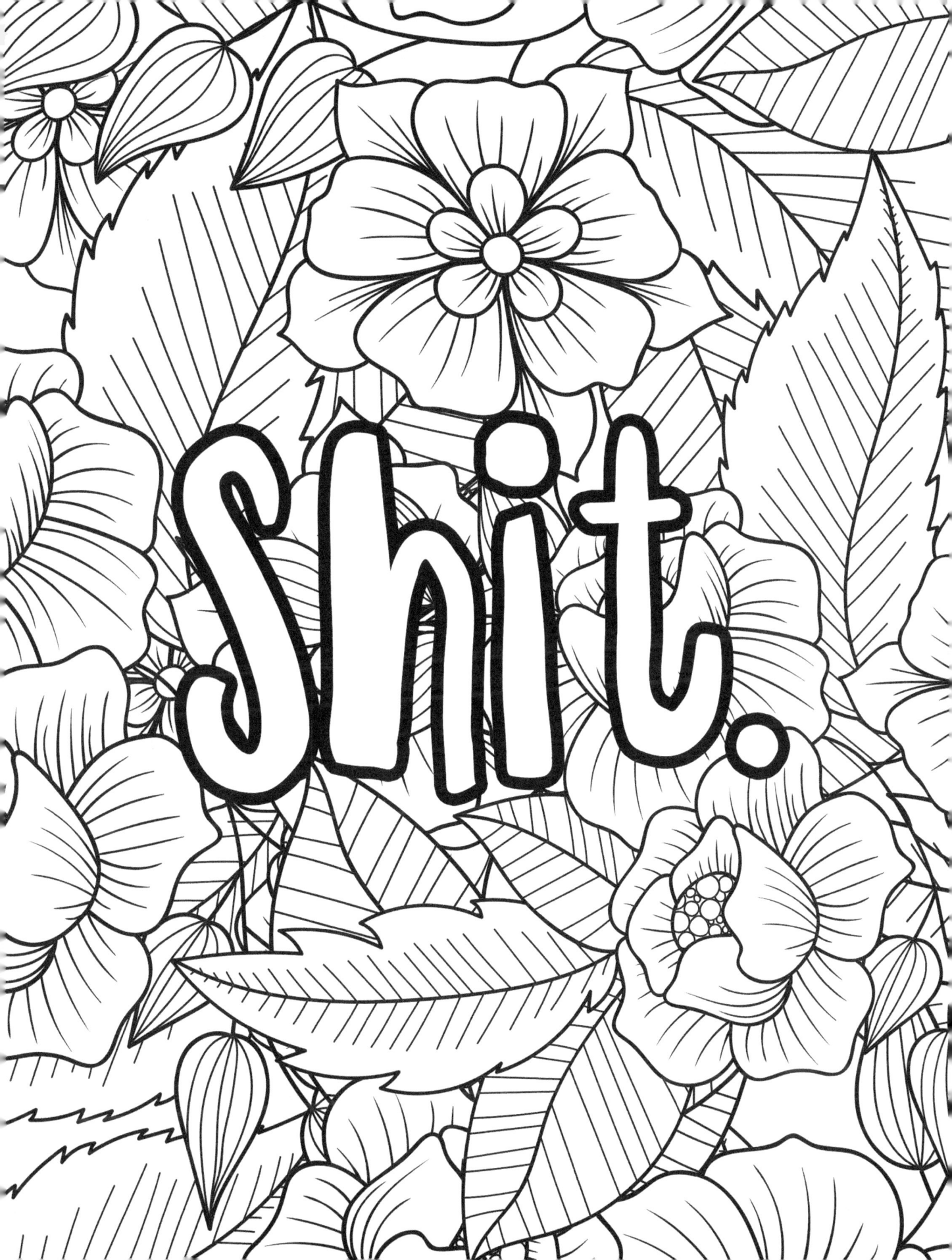

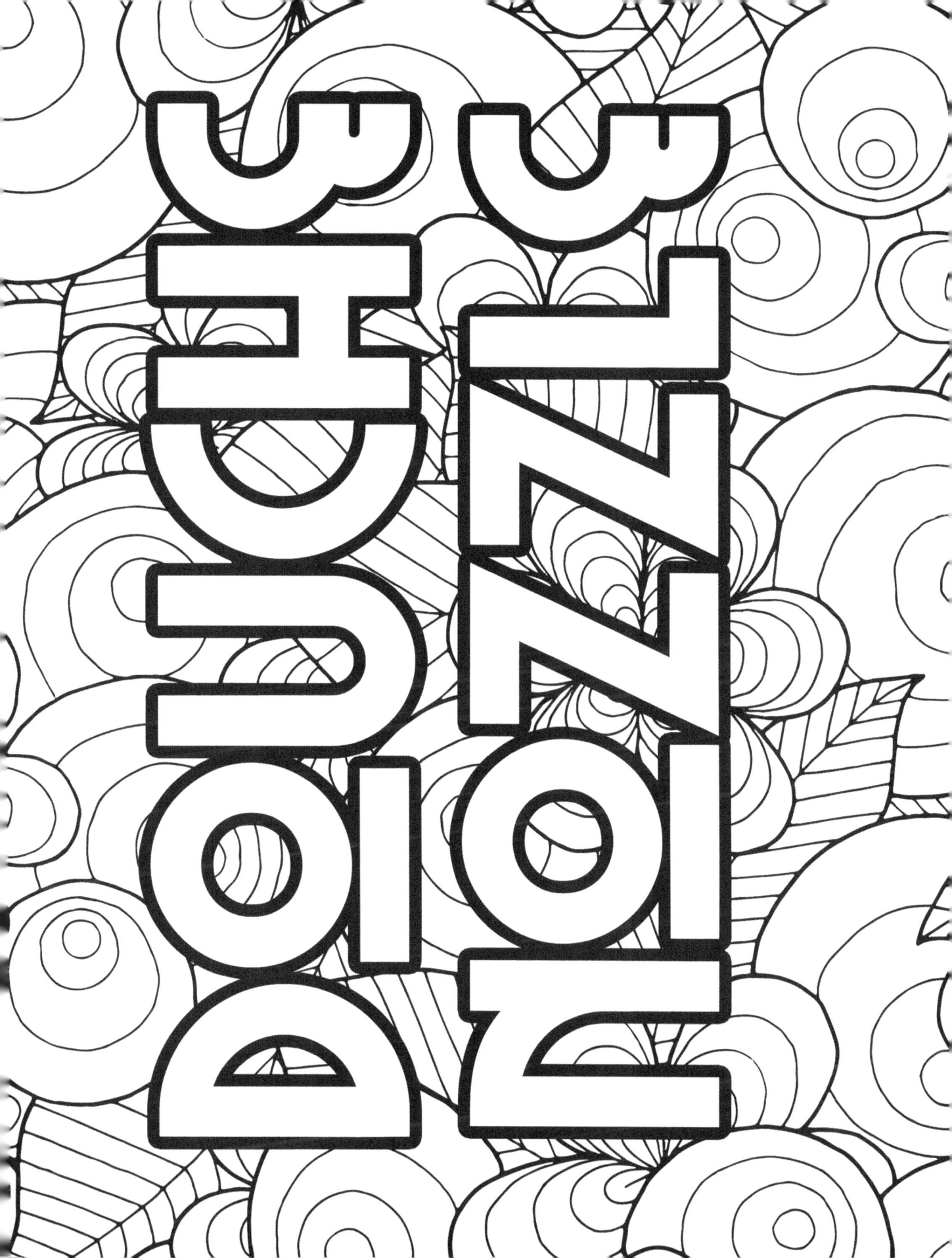

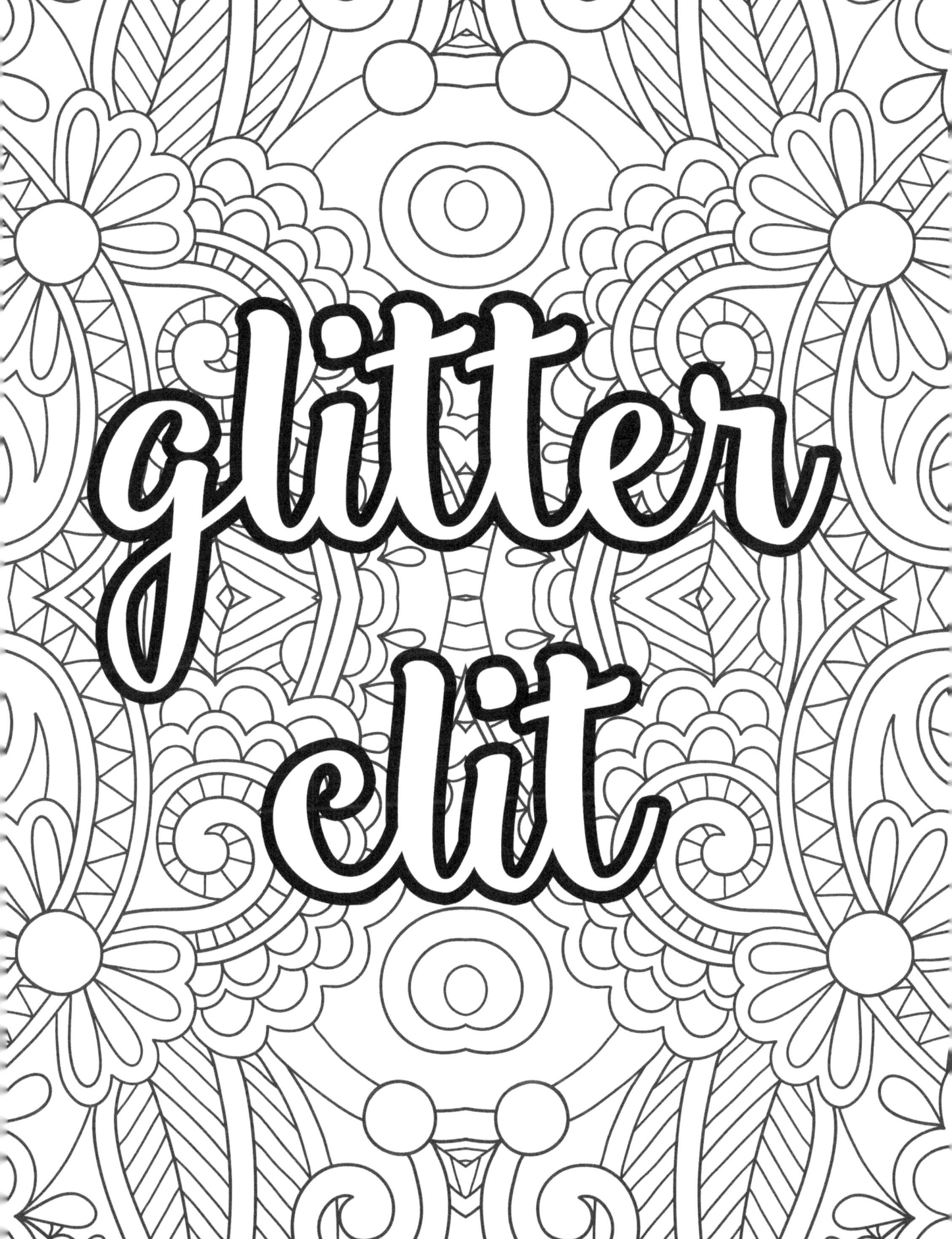

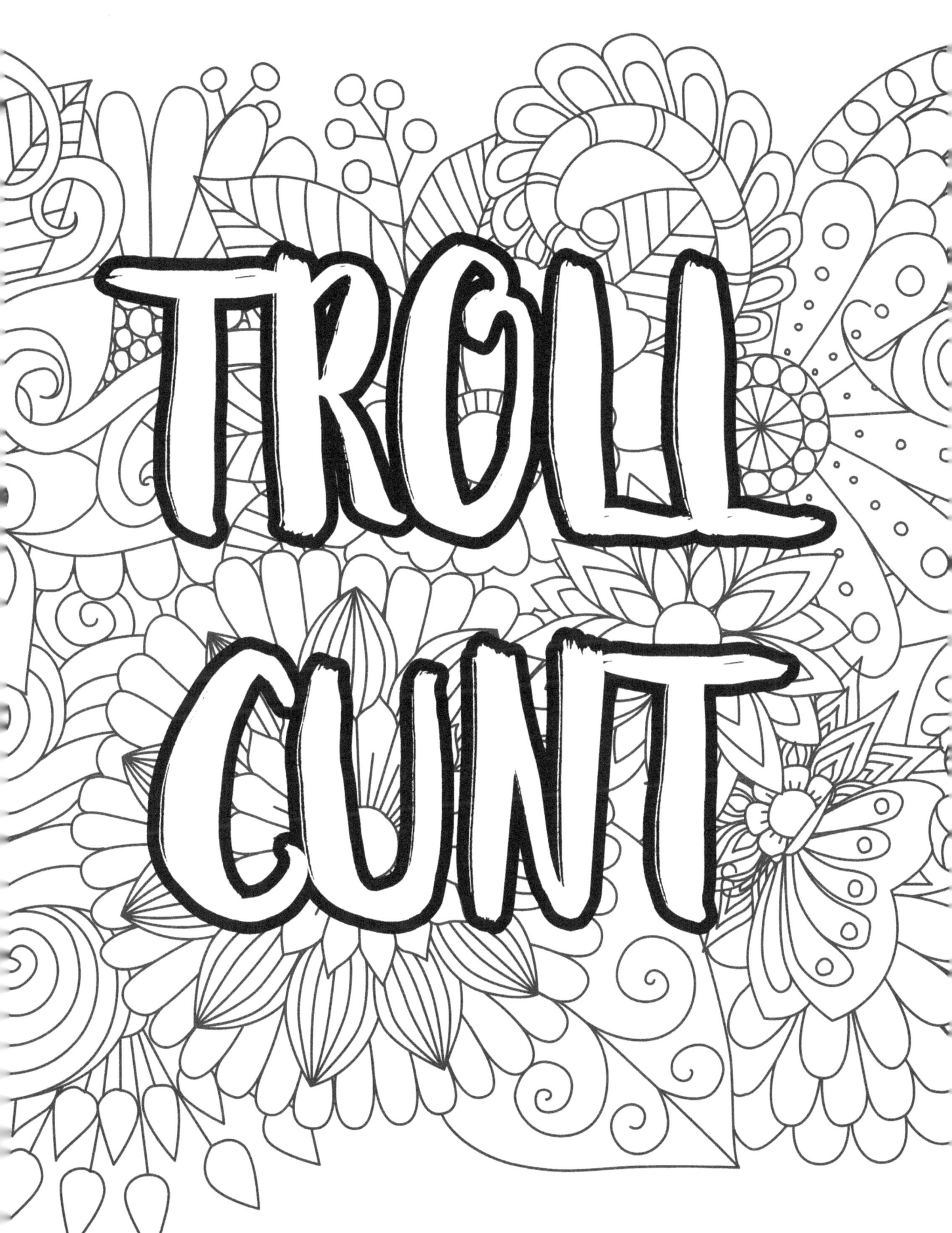

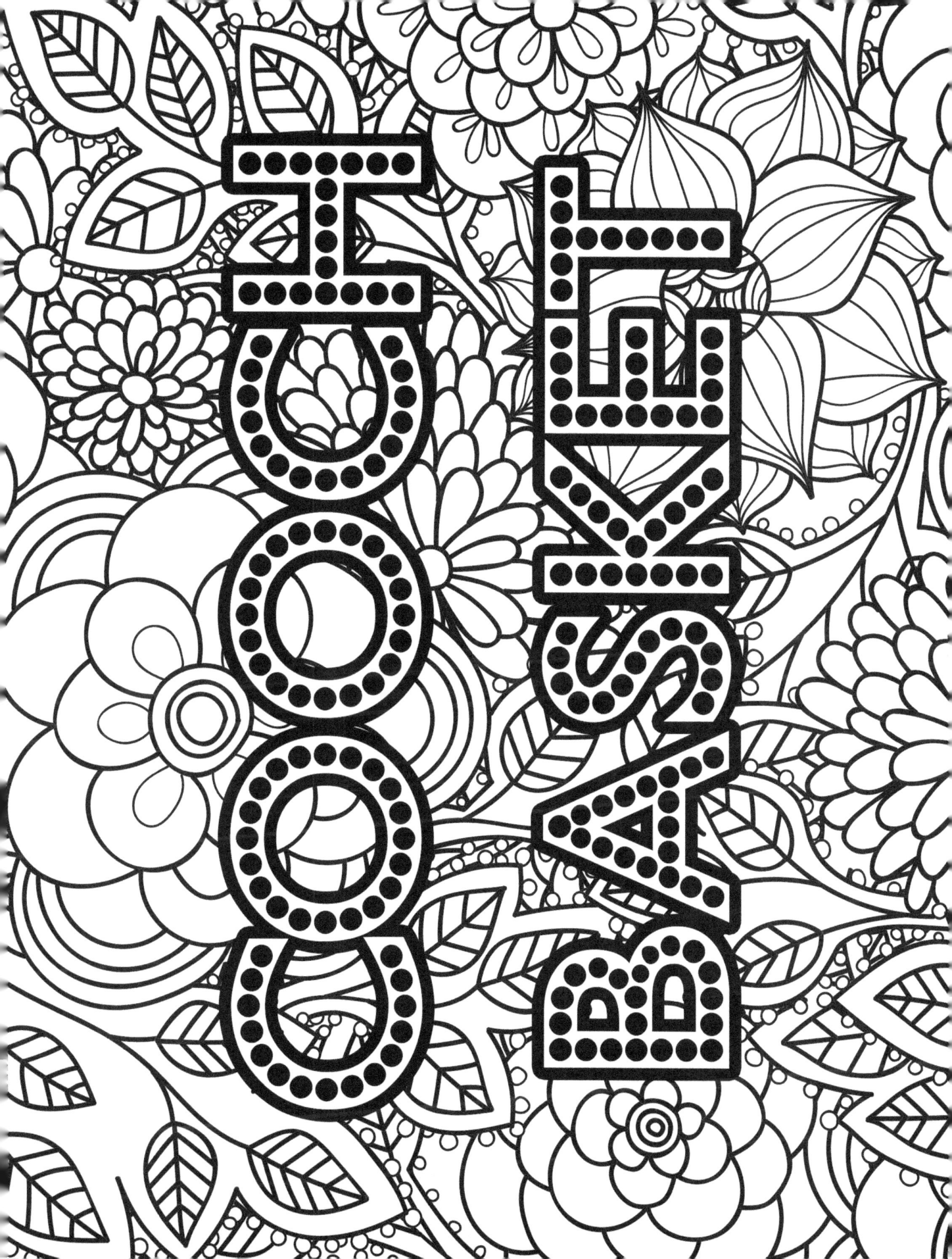

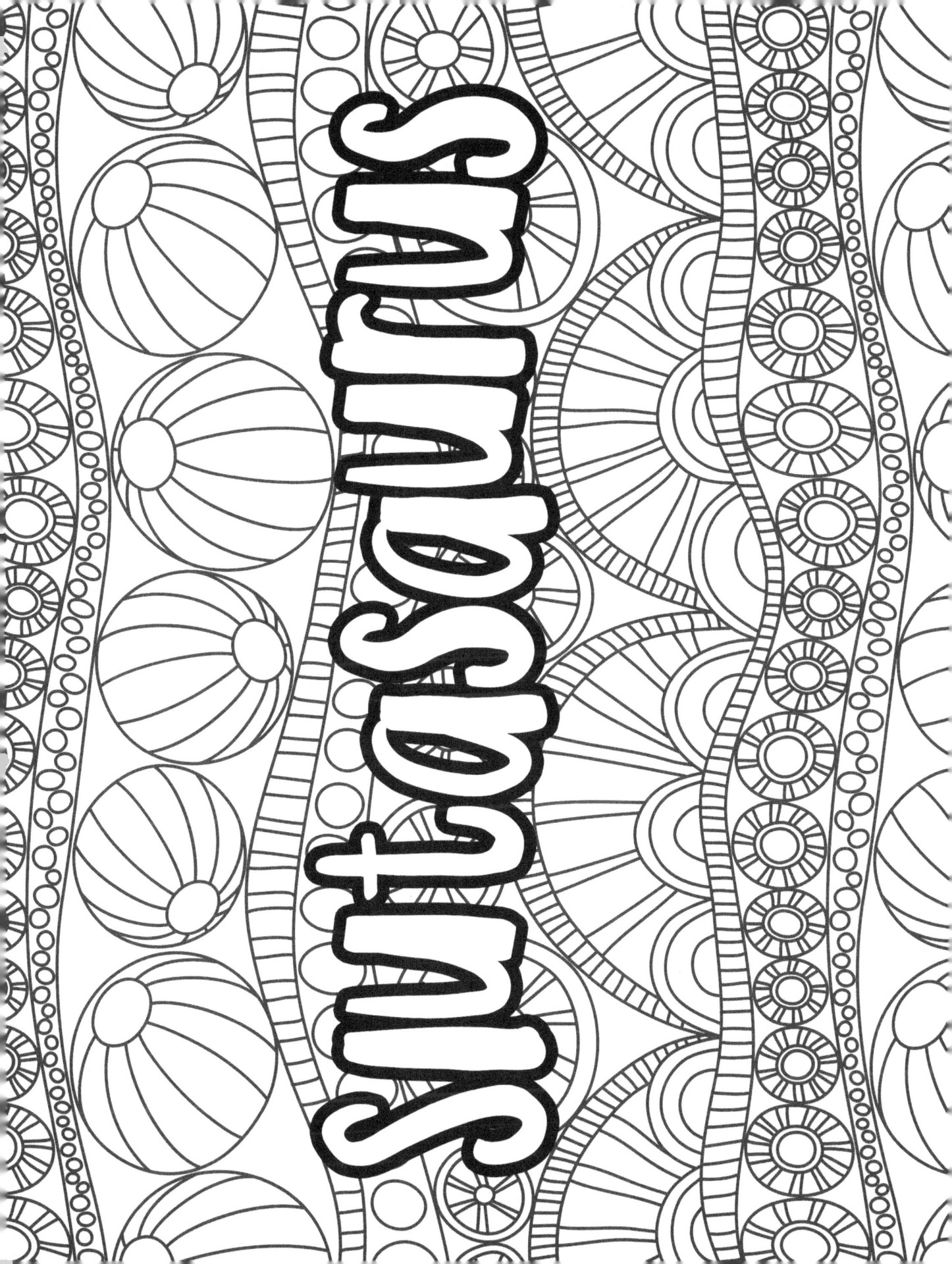

www.ingramcontent.com/pod-product-compliance
Lightning Source LLC
Chambersburg PA
CBHW080539190526
45169CB00007B/2560